THE ESSENTIAL
Roman Baths

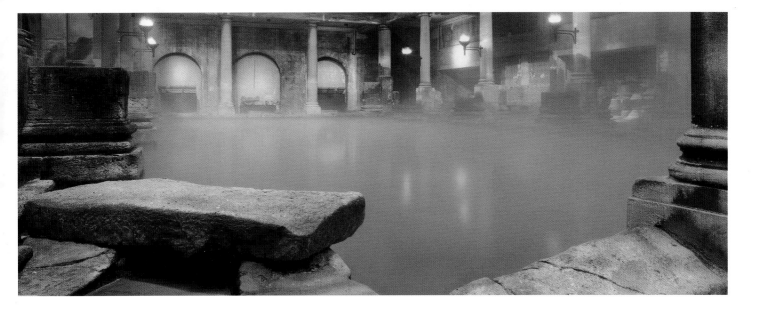

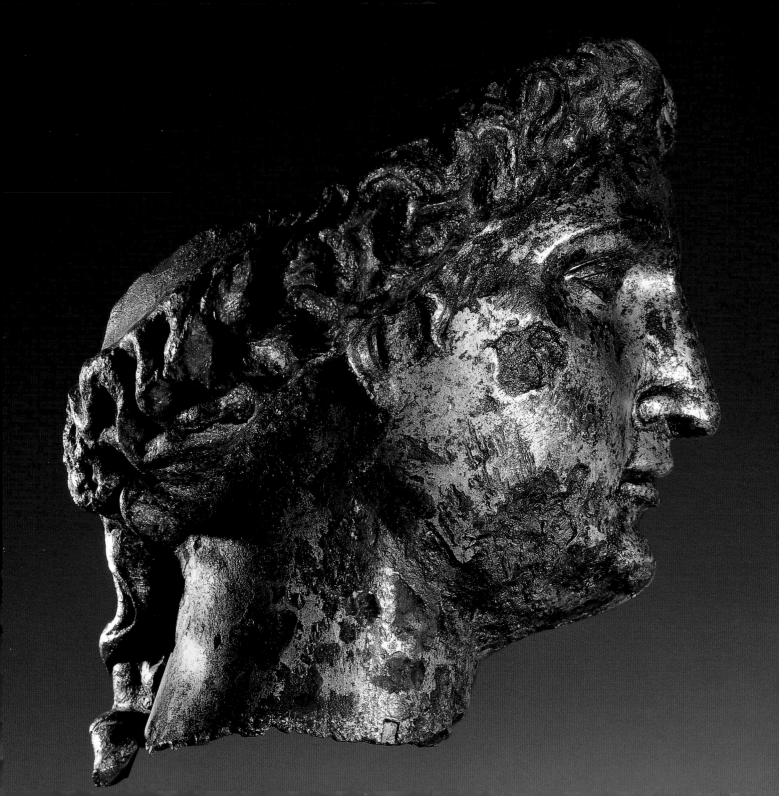

Contents

Introduction

The Roman Baths at Bath, animated by Britain's only thermal springs, is the most dramatic public building of Roman Britain. Although comparable in size with the bath-houses of other major towns in the province, these baths are more complete and in places stand up to three metres high.

Over the past 300 years antiquarian observations, Victorian investigations and twentieth century archaeological excavations have pieced the record together and revealed most of the complex to public view. Work in the Sacred Spring beneath the King's Bath in 1979–80 contributed much to our knowledge and understanding of how the Romans built around the thermal water and then used it for comfort, cure and cleansing.

The magnificent Temple of Sulis Minerva was a classical masterpiece worthy of Rome itself and architectural fragments and richly-ornamented blocks from its front facade are among the most important exhibits in the Museum. The remains of the open-air Temple courtyard, and of buildings around it, were excavated in 1981–83 beneath the Grand Pump Room and can now be seen as part of the visit.

The collections of the Roman Baths Museum are 'Designated' by the Museums Libraries and Archives Council as being of national importance. Coins and curses thrown into the Sacred Spring as petitions to the presiding Goddess, and inscriptions recording local people and well-travelled pilgrims, reflect the power of the hot springs to stir the superstitions and imagination of people in the ancient world.

The hot springs of Bath

T he continuous gush of hot mineral water which bursts from the ground in the centre of Bath has always been a subject of wonder. Imagine the scene 2000 years ago before the Romans came to tame the natural flow: a hot bubbling pool of murky green, overflowing in a narrow stream to the river, the stream and pool fringed red with iron salts and everything overhung, on cold winter days, with a pall of wisping steam. Little wonder that people believed the gods presided here.

The water we see today fell as rain on the Mendip Hills many hundreds or even thousands of years ago. It percolates down through limestone aquifers to a depth of between 2,700 and 4,300 metres where natural heat raises the temperature to between 64° and 96°C. Under pressure the heated water rises to the surface along fissures and faults through the limestone beneath Bath.

In the Middle Ages belief in the power of the thermal water re-emerged in the legend of the prehistoric Prince Bladud, son of Ludhudibras. In the ninth century BC, it was said, Bladud contracted leprosy, was banished from the court and took up work as a country swineherd. In time he noticed that when his pigs went to wallow in a steaming swamp in a valley bottom, they emerged cleansed of their warts and sores. Convinced that his own condition could be cured here, he plunged into the thermal mire and scrambled out without a blemish. He was accepted back into his father's court and, in grateful thanks to the curative springs, the city of Bath was founded around them.

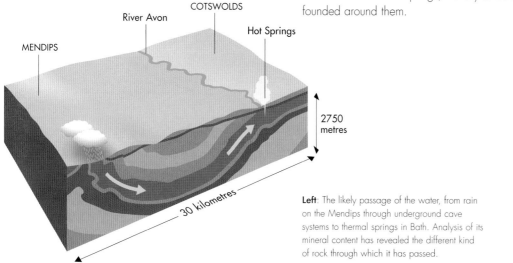

MENDIPS

River Avon

COTSWOLDS

Hot Springs

2750 metres

30 kilometres

Left: The likely passage of the water, from rain on the Mendips through underground cave systems to thermal springs in Bath. Analysis of its mineral content has revealed the different kind of rock through which it has passed.

Opposite: The statue of Prince Bladud, the legendary founder of Bath, has presided over the King's Bath since the seventeenth century.

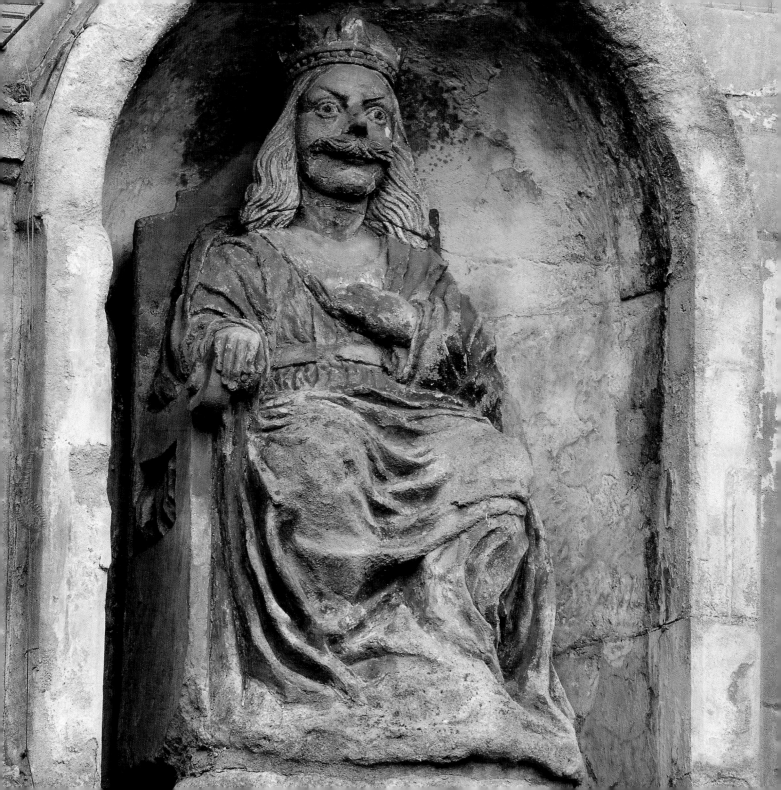

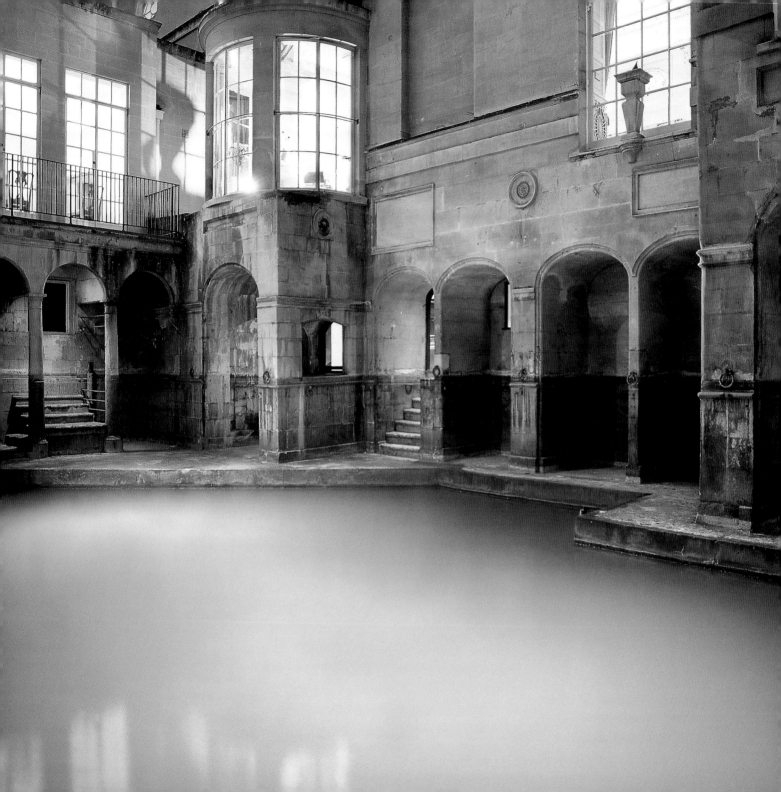

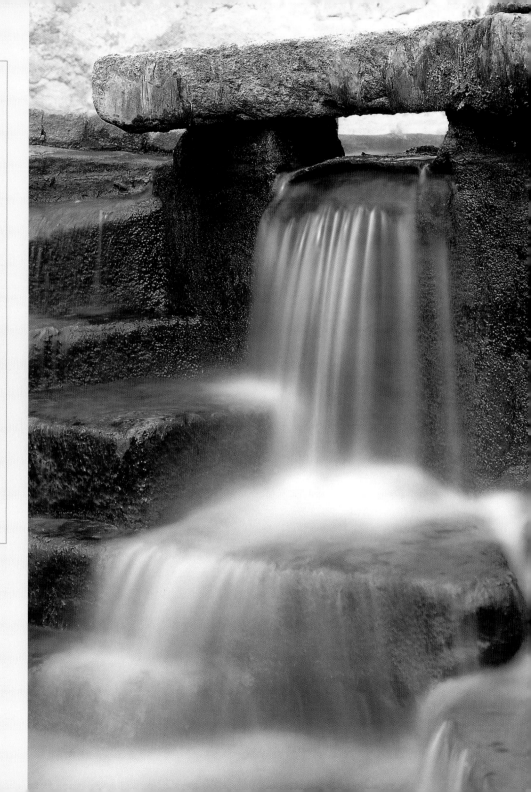

Spa water facts

Rate of flow: 13 litres per second, or 1,106,400 litres (about 250,000 gallons) per day.

Temperature: 46°C (115°F).

Mineral content:

- There are 43 minerals in the water.

- Calcium and sulphate are the main dissolved ions, with sodium and chloride also important.

- The water is low in dissolved metals except for iron, which causes the orange staining.

- The bubbling in the King's Bath is caused by exsolved gases escaping.

Colour: The water is colourless but acquires its distinctive green hue from algae growth caused by its heat and by daylight.

Drinking the water: Spa water may be tasted in the Pump Room. It is drawn up through a borehole sunk below the King's Bath.

Left: The King's Bath with the eighteenth century Pump Room beyond. The water is at the level it would have been at in Roman times.

Right: The hot water still gushes into the Great Bath through the original Roman channels.

The Romans arrive

By the first century BC this part of Britain was ruled by an Iron Age tribe called the Dobunni. They believed that the hot spring was sacred to the Goddess Sulis who, in common with many deities of rivers and springs, was probably thought to possess curative powers. At the spring it was possible to communicate with the underworld through the religious caste, the Druids, but the Goddess would first have to be placated with offerings.

In AD 43 the Roman armies landed on the south coast of England to begin their relentless task of conquering Britain. The initial aim of the Emperor Claudius was to conquer only the productive and more civilised south-east. The new province was protected by a wide military zone stretching across the country from Exeter to Lincoln and served by a military road now known as the Fosse Way. At intervals along the road, particularly where there were river crossings, forts were built. One of these probably lay in or near Bath, although proof of its location has yet to be found.

For the Dobunni the Roman invasion brought dramatic change. Early in the year AD 43 the great spring festivals would have been celebrated in the time-honoured manner. By the next year most of their land was occupied by the alien Roman force and this most sacred site, the spring of Sulis, had been swallowed up within the heavily patrolled military zone.

The Romans were sensitive to the gods and goddesses of those they conquered. These native deities were powerful forces who demanded respect. It was only the influential Druids, with their human sacrifices and, more worrying, their ability to stir up trouble for the Romans, who had to be annihilated. Thus Sulis and her Sacred Spring remained while the landscape around them began to change.

Above: Eighteen silver pre-Roman coins have been found in the Sacred Spring. Most of them are coins of the local tribe, the Dobunni.

Right: Statue of the Emperor Claudius. It is one of eight Roman emperors and generals by the sculptor G. A. Lawson, installed overlooking the newly discovered Great Bath in 1895–97.

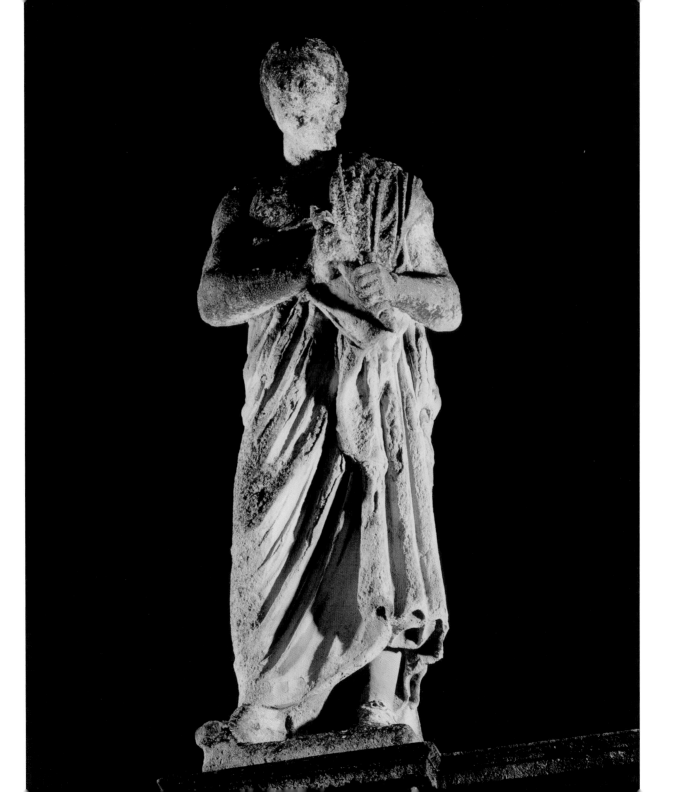

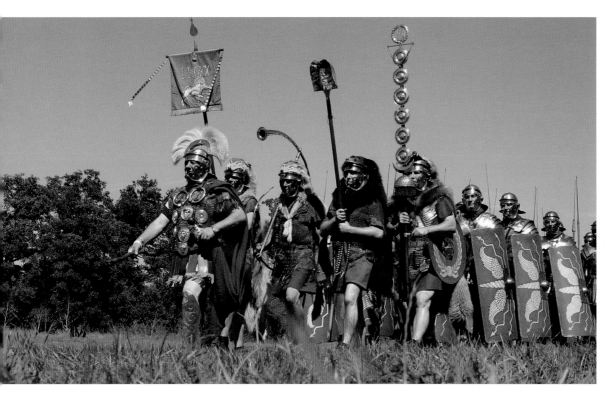

We know little yet about the early years of Roman Bath. The fort is unlikely to have been in use for more than a few years before the army advanced into the West Midlands and South Wales. But during this time there can be little doubt that the soldiers learned of the power of the Goddess: many would have paid their respects and some may have used the curative hot waters for bathing.

In the decade from about AD 50–60 the crossroads which grew up at the river crossing attracted traders and artisans, mostly native people but a few retired soldiers as well, who settled on the outskirts of the sanctuary. Early military tombstones in the Roman Baths Museum reflect the army's interest in the area. For example, Antigonus from Nicopolis in Greece, a veteran of the 20th Legion, probably retired to live near Bath and was eventually buried in the military cemetery alongside the Fosse Way.

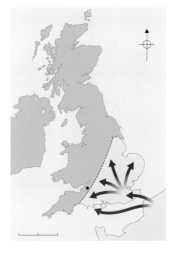

Right: Between AD 43 and 47 the Romans subdued the south and east of England. From the earliest years of the occupation Bath lay at the interface of the native British and Roman worlds.

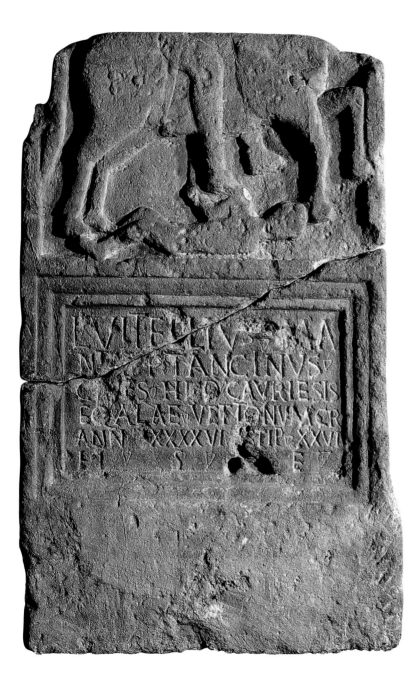

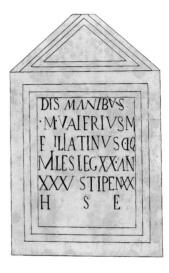

In AD 60 a devastating rebellion broke out, led by the British queen Boudica. Many thousands were killed and the revenge of the Roman military was uncontrolled in its violence. By the end of the episode the province lay in ruins. It took ten years to repair the physical, psychological and political damage that had been done in the few months of fury.

It was probably during this period of reconstruction that the Roman authorities took the decision to turn the native sanctuary of Sulis into a magnificent curative establishment, perhaps a symbol of reconciliation.

Left: Tombstone of auxiliary cavalryman L. Vitellius Tancinus from Spain, who was probably buried in a military cemetery outside Bath. Cavalry units were used extensively for policing duties in frontier areas.

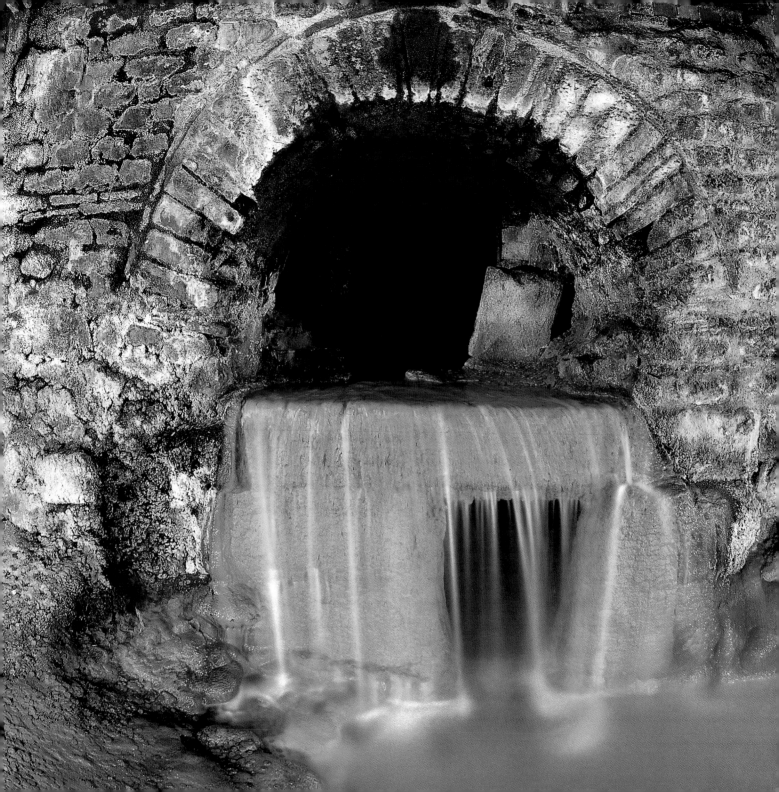

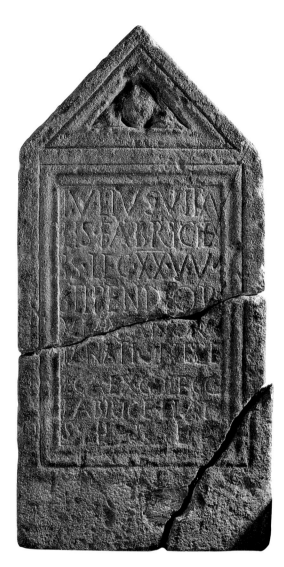

Taming the springs

The construction of the Baths could only begin once the hot spring had been controlled and the land around it drained and dried out. The precise hydraulic engineering shows the skill of the Romans in the art of taming natural springs.

They began by consolidating the unstable ground around the spring with oak piles driven deep into the mud. They then enclosed the spring within a massive reservoir wall two metres high, lined with lead sheets to make it watertight. The reservoir provided a head of water to feed the Baths, and it served as a settling tank for the sediment, brought up by the force of the spring, to prevent it from blocking the narrow pipes.

Below: A Roman lead pipe still in its original position in a gully cut into the pavement beside the Great Bath.

Above: Tombstone of Julius Vitalis, armourer of the Twentieth Legion who died at Bath. The Twentieth Legion may have been involved in the construction of the Baths.

Left: This impressive arched overflow was part of the Roman engineering arrangements which still keep the hot water flowing through the complex today.

Right: Diagram illustrating the elaborate system of channels that distributed water around the Baths. Hot water came from the Sacred Spring but cold water would have come from sources outside the Baths.

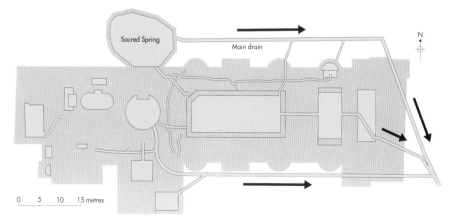

Sacred Spring

Main drain

N

0 5 10 15 metres

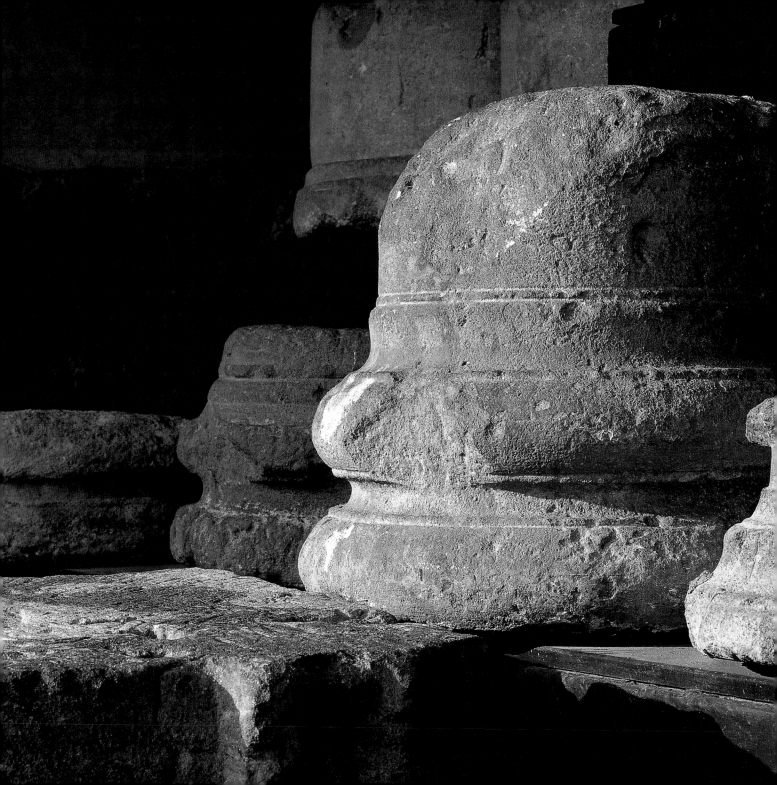

Building the Baths

The building of the Baths and Temple was one of numerous construction projects in southern England embarked upon by the Romans to demonstrate their commitment to rebuilding the new province in the wake of the Boudican Revolt of AD 60–61. Great care was needed in planning such a bold venture; care, because they were intervening in the realm of the presiding native Goddess Sulis; and because then, as now, the natural phenomenon of the hot springs was a fragile environment. The Romans evidently dealt with both issues successfully and by about AD 75 the task was complete.

Above: Inscribed fragment, probably from an altar or dedication, referring to the seventh consulship of the Emperor Vespasian, which was in AD 75. It was probably found in the Baths and may record the year when building work was completed.

The Roman army would have undertaken the considerable logistical exercise of building the Baths. Local timber, building stone from the downs to the south of the river Avon and lead from mines on the Mendip Hills were brought to be fashioned and finished on site. Clay tiles probably came from tileries to the east in Wiltshire. Surveyors, engineers, plumbers and a host of other tradesmen would have been employed in the work.

Anticipating the ambitious scale of the Baths planned for the south of the spring, the Romans blocked the natural stream draining away to the river Avon and built a new stone-lined drain to channel the water away to the east. This remarkable act of foresight meant that the main outfall drain, whose preservation was crucial to the continual discharge of large volumes of water, did not have to pass beneath the heaviest parts of the buildings and remained accessible for maintenance.

Right: Box tiles were used in the vault covering the Baths, being light and strong and providing an insulating layer. Surfaces were combed before the clay was fired to help mortar and plaster adhere. Sometimes stray animals in the tile works would step on unfired tiles and have their imprints preserved.

The original Baths were elegant in their simplicity. They were planned in three distinct parts: a spacious entrance hall overlooking the Sacred Spring to the north, a simple suite of steam rooms heated from beneath by hypocausts to the west, and three thermal swimming baths to the east.

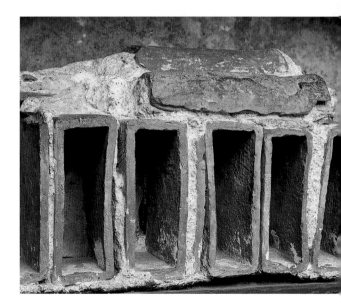

The Great Bath was the largest of these pools and the heart of the bathing establishment. This elegant hall consisted of a rectangular swimming bath surrounded by broad walkways paved with hard white lias slabs. Six alcoves were set into the outer walls of the chamber to provide space for people to sit and relax away from the splashing of other bathers. The Great Bath was always roofed, initially with timber but later with a heavy brick and tile vault supported by massive stone piers. A high-level tier of windows admitted light and gave the hall a tall, basilica-like appearance.

The pool itself was flat-bottomed and 1.5 metres deep with steep steps down into it on all sides. The original lead lining on the base survives in three rows of fifteen sheets; the three smaller sheets at the western end suggest that they were originally laid from east to west with the end row of lighter sections being laid last.

The hot spring water flowed constantly into the Great Bath through a lead box culvert at its north-western corner, as it does today. Some water passed to other baths at the east end but the excess was taken away through a sluice-controlled drain in the north-east corner and fed into the main overflow drain. The water level in the Great Bath was maintained by a bronze sluice found in its original position by the excavators in 1880. The system was simple but highly effective, the constant flow keeping the Baths hot and the drains clear.

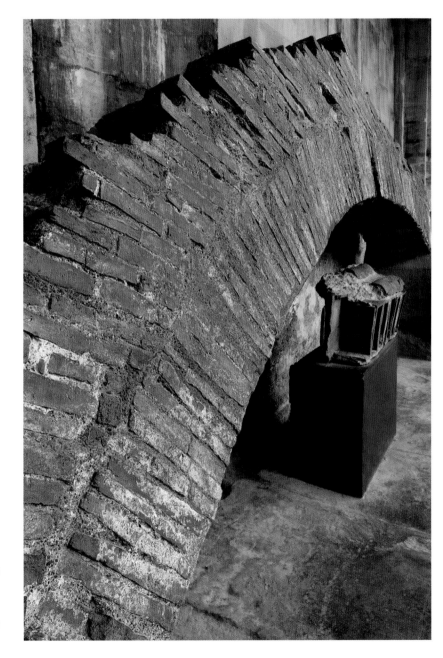

Left: The Great Bath is still lined with 45 sheets of Mendip lead, laid to prevent cold ground water from cooling the bath. The raised joints between the sheets are clearly visible.

Right: The use of lime mortar with crushed tile in it enabled the Romans to construct ambitious roof structures. Timber formwork would be erected and the tile and mortar roof laid over it. When the mortar had set the formwork would be removed.

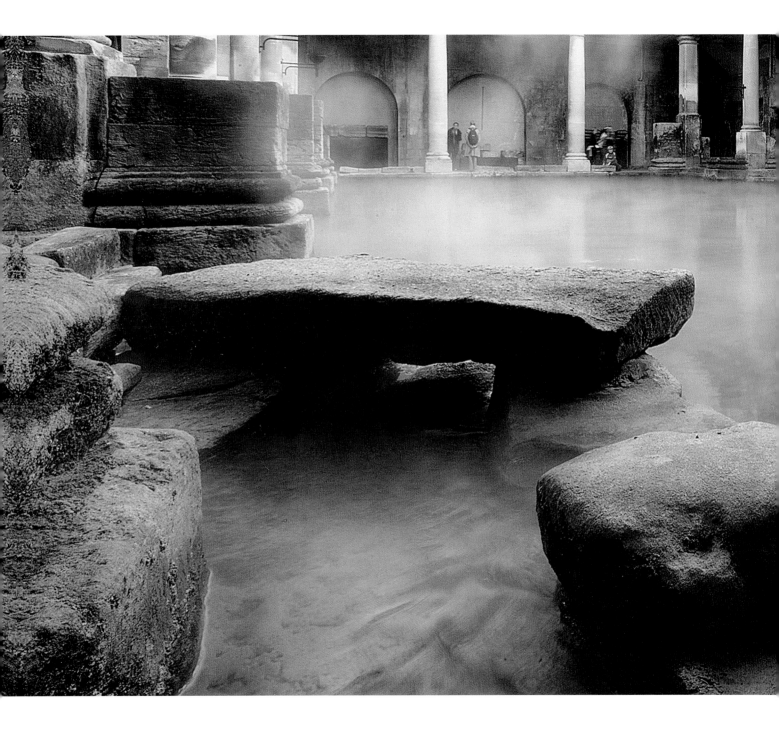

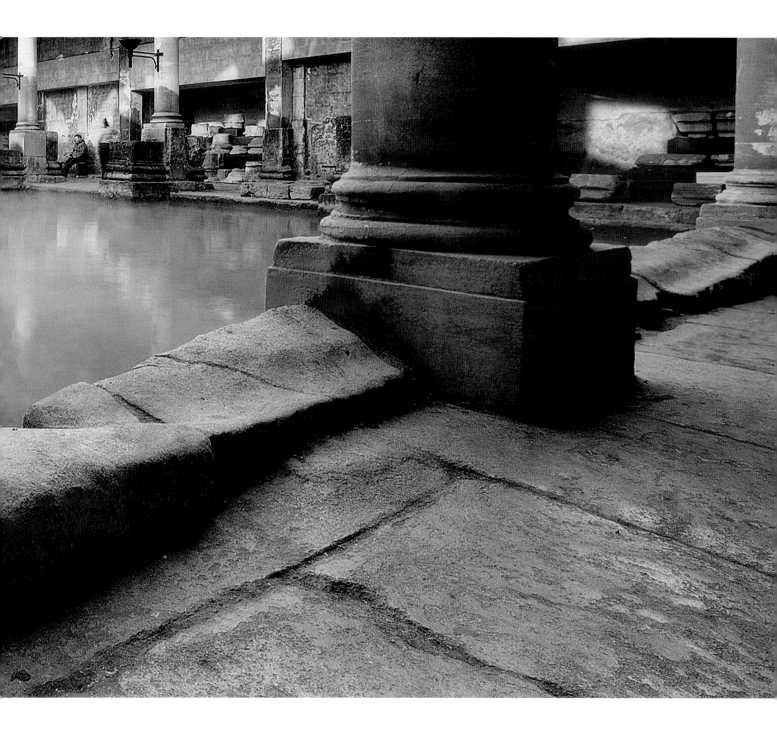

Throughout the complex the interior walls were plastered and painted, probably with a simple scheme of geometric panels. Patterned mosaics decorated the floors although there is little evidence of them today. Iron-framed windows, probably glazed, would have admitted light to the heated rooms and the alcoves around the Great Bath.

Despite its architectural splendour the establishment could not function without the essential services being built into the structure behind the scenes. Lead piping and bronze sluices ensured the supply of hot water and steam to the different bathing facilities, while brick stokeries, underfloor supports (*pilae*), flues and chimneys allowed hot air from furnaces to circulate beneath the treatment rooms. Copper boilers would ensure hot water even in those parts of the Baths that were at some distance from the hot spring.

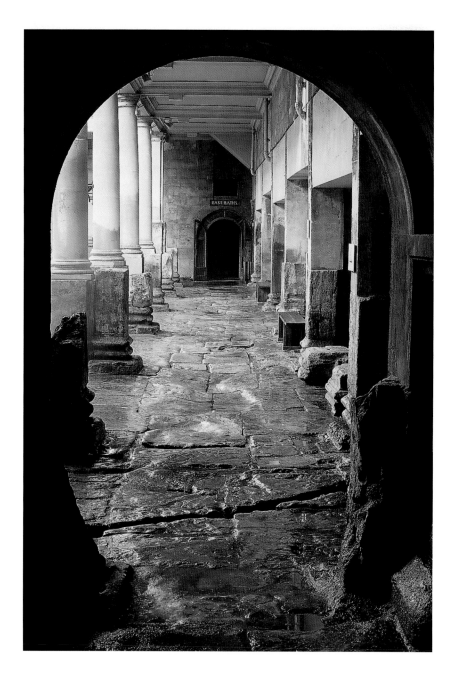

Right: The Roman paving on the south side of the Great Bath, flanked by the moulded bases of the stone piers that supported the Roman roof that covered the building.

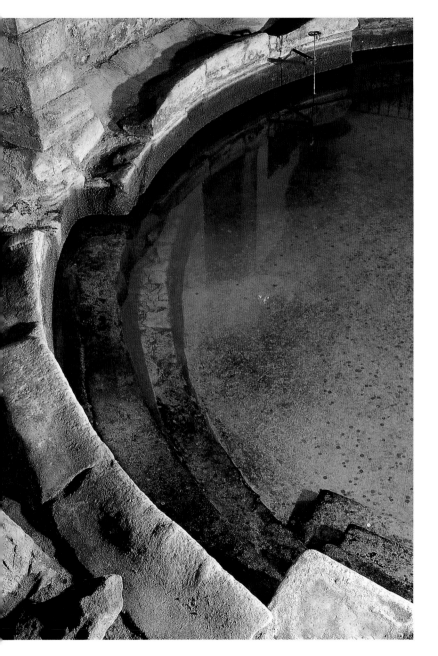

Cleansing and relaxing

O ne of the later Roman emperors was asked by an incredulous barbarian chieftain why he bathed once a day. The emperor answered in apologetic innocence that it was because he was now too busy to bathe twice. Bathing was extremely important in Roman society.

At their simplest a suite of baths would comprise an undressing room (*apodyterium*), a cold plunge bath (*frigidarium*) and warm and hot steam rooms (*tepidarium* and *caldarium*) with underfloor heating, or hypocausts. Some larger establishments like Bath also had the added sophistication of a sauna-like room of intense dry heat (*laconicum*).

After taking exercise, the bathers would undress and acclimatise to the warmth of the *tepidarium* before moving on to sit and sweat in the *caldarium*. Here they could demonstrate their social status by the number of their attendants and the fragrance and quality of the oils with which they were massaged. They would then complete their regime with a quick cold plunge in the *frigidarium* to rinse off and close the pores.

Left: The Circular Bath, where bathers completed their visit to the steam rooms with a cold plunge to rinse off, freshen up and close the pores of their skin.

Computer reconstructions help us understand what the Baths might have looked like in Roman times. These stills are taken from animations showing in different parts of the Baths.

Mixed bathing in public was not uncommon at first but in the more prudish times of the second century the Emperor Hadrian passed a law forbidding it. Thereafter public baths had different opening hours for men and women but some establishments, of which Bath seems to have been one, built additional facilities so that both sexes could be accommodated at the same time.

▲ The rectangular tepid bath in the East Baths with doors leading into the adjacent suite of heated rooms.

▶ The *tepidarium* or warm room in the West Baths suite of heated rooms. The doorway in the far corner can still be seen today.

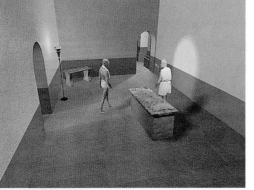

Below: The hypocaust, or underfloor heating system, that supported the *tepidarium* in the West Baths. Few people would ever see the hypocausts except the unfortunates charged with clearing them of soot.

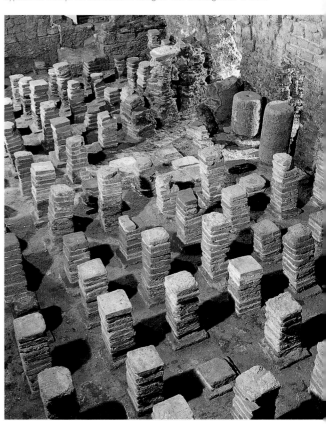

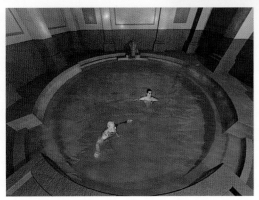

◀ The cold water Circular Bath. The walls around this bath still have extensive areas of Roman plaster on them, although their colour scheme is no longer evident.

The Baths provided a context for social interaction to take place. Sitting in the alcoves away from splashes from the pool, people would meet with clients to discuss business and debate the issues of the day, listen to the discourses of philosophers, play board games, gamble and eat and drink. They would have entertainers like jugglers and musicians present, manicurists and even armpit-pluckers, as well as hosts of servants and slaves running about attending to their masters. Bathing was a noisy, lively pastime essential to an agreeable life.

No doubt the bathing establishment here would have functioned like any normal town bath-house. However, in Bath its function was also curative. Because of the thermal water provided by Sulis Minerva through the Sacred Spring, people came here to immerse themselves in the health-giving waters. It is for this reason that large swimming pools, rare in normal urban baths where heating water was a great expense, are such a dominant feature of the Roman Baths at Bath.

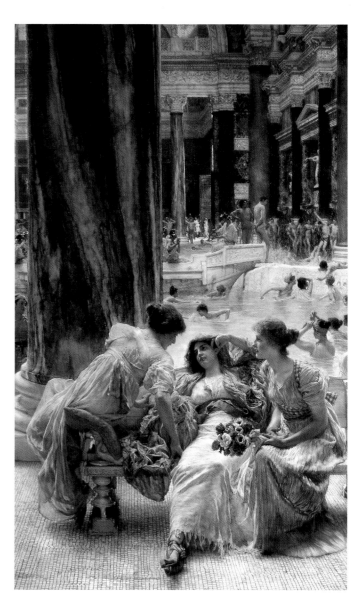

Right: A bathing set from the British Museum, common personal equipment for bathers. Scented oil from the flask was massaged into the body and a strigil was then used to remove the oil, sweat, dirt and hair from the skin.

Opposite: Intaglio gemstones found in the main drain, pictured at approximately 7:1 scale. Warm water probably softened the adhesive holding the intaglios into finger-rings, causing them to drop out.

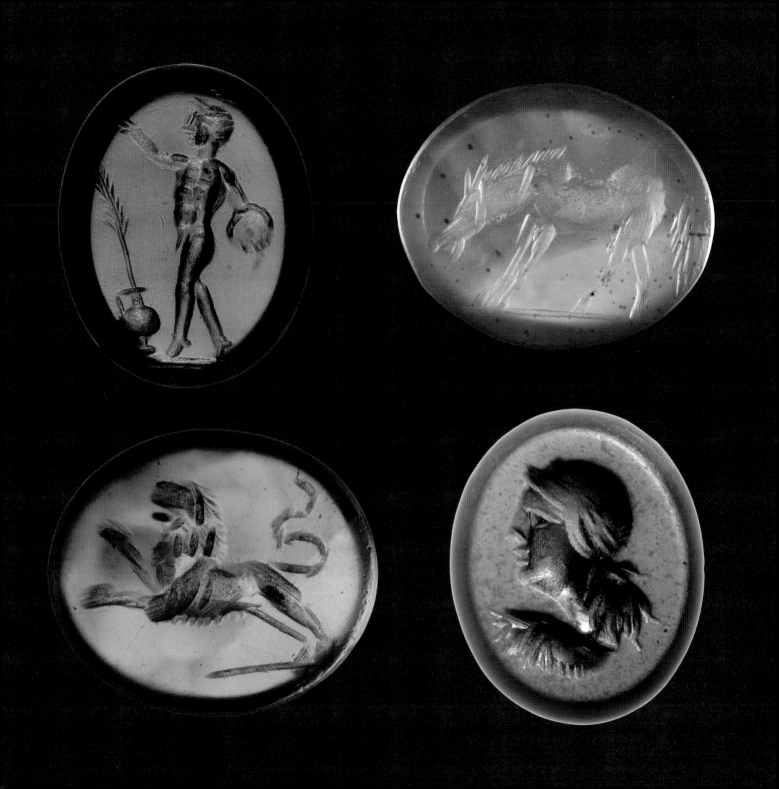

Power of the Goddess

The Sacred Spring was the point at which the human world could communicate with the presiding deity. Those requiring divine intervention made their wishes known to the Goddess, by performing a sacrifice or making a gift in anticipation of a successful outcome.

One way to ensure that the Goddess knew what was required was to inscribe a message on a sheet of lead or pewter and throw it into the spring. As with legal documents, it was important to get the wording exactly right and this may have involved the use of trained scribes. A number of these messages have been recovered from the spring. For the most part they are curses invoking the deity to punish a wrongdoer, someone who may have stolen a bath robe or a few *denarii* (silver coins). Usually the person placing the curse did not know exactly who the culprit was, but was able to provide a list of suspects. If the wrongdoer were named, the Goddess would know and could act. The threat of divine wrath would be a powerful deterrent.

The spring was also a place where gifts were made to the Goddess. Excavation has recovered thousands of coins, items of jewellery and a collection of pewter and silver dishes and handled cups, usually inscribed with a dedication to Sulis Minerva. These vessels may have been used for drinking the water, although carvings from elsewhere show them being used for pouring libations over small stone altars.

Immersion of the body in the spring water in the Baths was thought to have curative value. It was also believed in the ancient world that just being in the Temple or sleeping there would allow the healing powers of the gods to work.

Left: Candle holder in the form of a stag, one of a number of pewter objects found in the Sacred Spring in 1878–79. These items, probably manufactured near Bath, may have been made for use at the Temple.

Below: Two rare gold *aureii* of the British usurper Allectus (AD 293–96) thrown into the Sacred Spring, probably by a well-paid official.

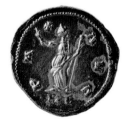

Left: Lead curse found in the Sacred Spring in 1879. Romantic interpretations have suggested that it records a girl – Vilbia – taken from her lover. However a reinterpretation of this otherwise unknown name points to a more mundane possession, such as a napkin, being stolen. Unsure of whom to blame, the complainant wrote a list of likely culprits.

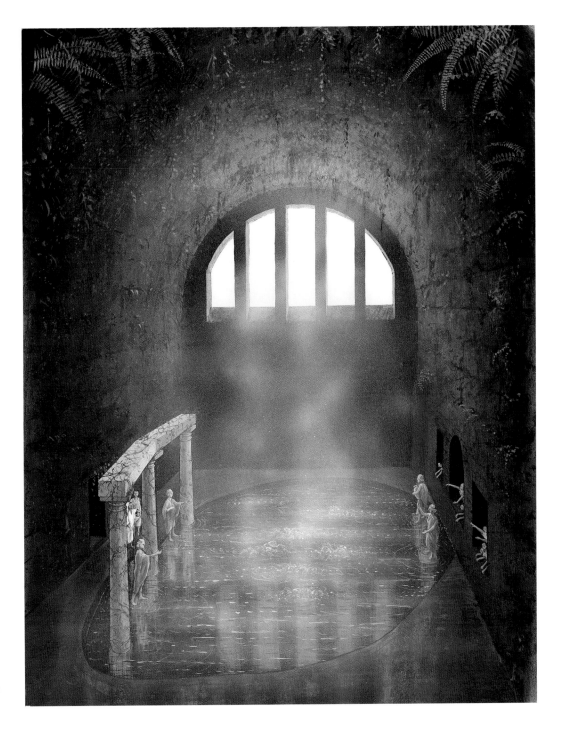

Right: Artist's impression of the Sacred Spring. The humid environment would have encouraged the growth of plants and the steam and subdued light would have created a mysterious atmosphere.

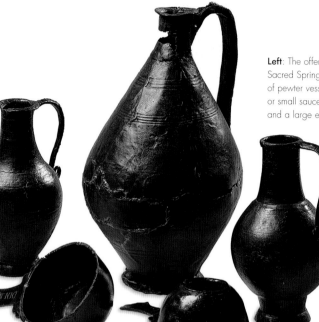

Left: The offerings cast into the Sacred Spring included a number of pewter vessels such as *paterae* or small saucepans, two flagons and a large ewer.

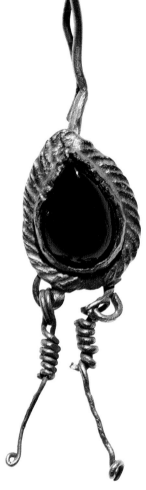

Right: Items of jewellery thrown or dropped into the spring included this delicate gold and garnet ear-ring.

The Goddess Sulis Minerva

Inscriptions reveal that the native and Roman deities were considered one and the same. Several libation vessels found in the Sacred Spring bear the legends *DSM* and *deae Suli Minervae*, "To the Goddess Sulis Minerva".

Two stone altars from other hot springs nearby carry the same dedication.

Left: Handle of a silver *patera* decorated with tendrils and rosettes and a punched inscription D SVLI.

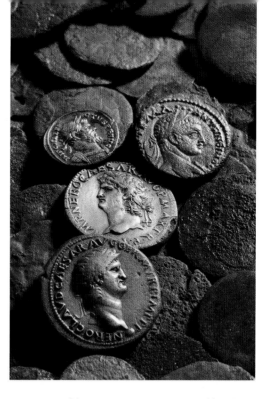

Above: Some of the 14,000 Roman coins excavated from the Sacred Spring. The majority were illegible due to the corrosive nature of the spa water.

Below: Bronze openwork sheet, possibly once mounted on leather or fabric as part of a priest's regalia such as a head-dress.

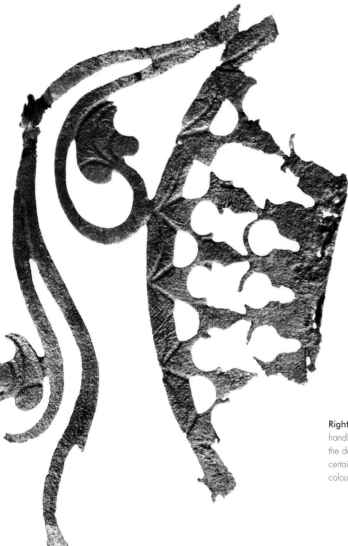

Right: Broken decorated handle of a bronze *patera*; the deep recesses almost certainly held brightly coloured enamel decoration.

Ceremony and sacrifice

he rituals in Roman religious observances generally took place out of doors on the paved area around the sacrificial altar, unlike the modern church or mosque, where participants in the ceremony congregate inside the building.

Public ceremonies sometimes involved the sacrifice of an animal to the deity. On these occasions an augur, or *haruspex,* would examine the beast's organs for marks or blemishes from which he could foretell the future. Inauspicious marks on the liver would be seen as an omen from the deity for the person who had commissioned the sacrifice to heed.

In 1965 an inscribed stone pedestal was found close to the sacrificial altar. It tells us that Lucius Marcius Memor, a *haruspex,* made a dedication to the Goddess Sulis, the item dedicated probably being a statue. This is the only recorded instance of an augur in Britain and an indication of the importance of the Temple at Bath.

In addition to the great sacrificial altar the precinct would have been cluttered with a number of smaller altars to the deity, set up by individuals in anticipation of a divine favour or in thanks for having received one. These stones were always inscribed with the names of the donors. Decked with flowers or supporting containers of smouldering incense, they would have added a vivid dimension to the sanctuary.

The Temple precinct must have been thronged with hangers-on – scribes writing the curses, sellers of religious trinkets and an oculist, whose stamp was found in Abbey Church Yard in 1731, selling his concoctions to cure eye complaints. Wherever there are people hoping to be cured, there are the unscrupulous who will prey on their frailty.

Below: Bronze model of an ox liver from Piacenza, Italy. It was divided into zones to help the priests interpret the blemishes they found on the livers of sacrificed animals.

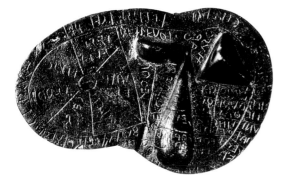

Right: The *haruspex* inscription. This kind of priest was evidently so rare in Britain that the centrally carved HAR denoting his rank was further spelled out with the addition of three more letters.

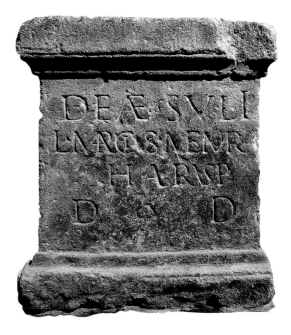

Tin mask probably used by priests in
temple ceremonies. The eye recesses
may have housed precious stones.
Holes around the edge suggest that
it was mounted on a wooden frame
rather than actually worn.

The Temple of Sulis Minerva

The Temple, in its original late first century form, was a purely classical building set on a high podium reached by a steep flight of steps. Its porch was dominated by four massive Corinthian columns supporting an ornate pediment. Behind lay a simple room, the *cella*, where only priests could enter to tend the flames kept burning around the life-sized cult statue of Sulis Minerva.

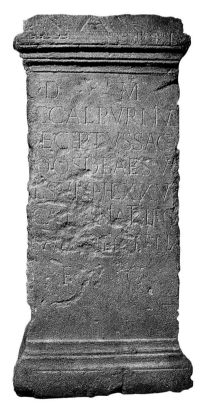

Above: Tombstone of 'G. Calpurnius Receptus, priest of the Goddess Sulis', who would have worked at the Temple. The memorial was erected by his freedwoman wife, Calpurnia Trifosa, in a Roman cemetery on the other side of the river.

The gilded bronze head from the cult statue is one of the treasures of Roman Britain. It was found in 1727 by workmen digging a sewer deep beneath Stall Street. The object is incomplete; its body has never been found and the form of the casting indicates that the statue once included a tall Corinthian helmet, a sign of her martial prowess.

At first sight, a classical icon like this might seem out of place at a spring dedicated to a native deity. But, faced with a spring sacred to Sulis, the Romans would have ascertained her renown for healing, wisdom and perhaps military insight, and deduced that Sulis was the equivalent of their own Minerva. Thereafter the names Sulis and Minerva were interchangeable and sometimes appear together on inscriptions.

The Temple faced a paved yard towards the centre of which was the sacrificial altar, so sited as to be on the east–west axis through the Temple and the north–south axis across the spring.

Gradually modifications were made to this simple arrangement. In the second century the Sacred Spring was enclosed within a massive vaulted chamber (see diagrams on page 39). Now the only access to the waters was through a small door opposite the sacrificial altar, but they were visible through three large openings from the Baths to the south. At the same time the Temple podium was broadened to create an ambulatory, and small shrines were built beside the Temple steps.

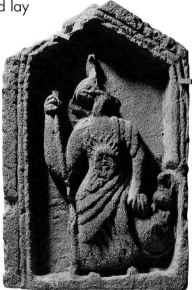

Above: Relief carving of Minerva found during the excavation of the Great Bath in 1882. She is wearing a breastplate in the form of a gorgon's head mask.

Opposite: The gilded bronze head from the cult statue of Sulis Minerva that once stood inside the Temple where only the priests would attend to her.

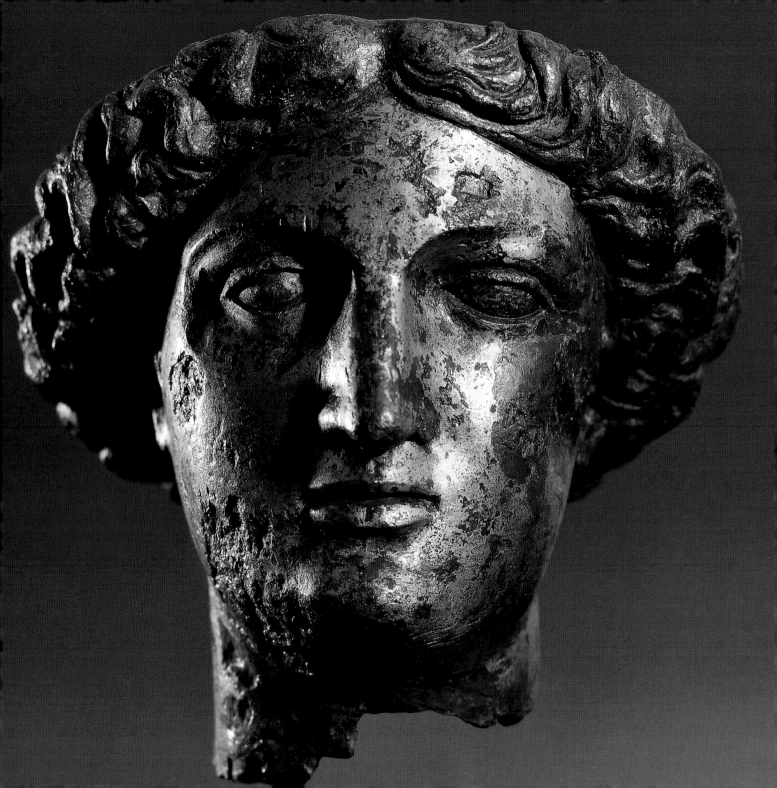

Later the north wall of the reservoir building began to tip outwards under the weight of its vault. This required massive buttressing cleverly disguised in an ornamental style, with the central buttress taking the form of a two-way arch and pediment framing the door to the spring. To balance this, a new building decorated with cupids and the four seasons was built on the north side of the altar. Carved blocks from this structure can be seen in the Museum but its exact position is not known.

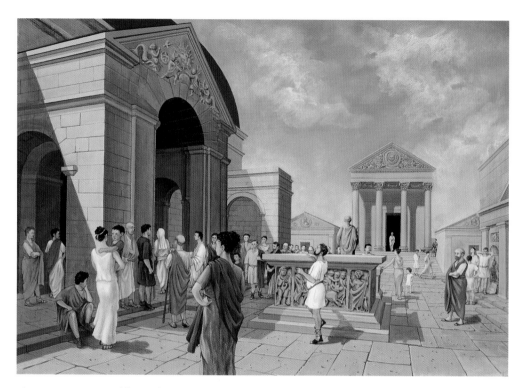

Above: Artist's impression of the Temple precinct, made nearly 20 years before the computer animations below. It conveys very well the enclosed nature of the inner Temple precinct around the sacrificial altar.

◀ Still frame from a computer animation of the Temple precinct, looking towards the Temple itself. The two side temples were erected in the later Roman period and are similar in style to Romano-Celtic temples elsewhere in the west of England.

◀ Still frame looking in the other direction, from the Temple steps towards the centrally-sited sacrificial altar. The building that enclosed the Sacred Spring can be seen on the right. The two steps in front of it are still clearly visible today.

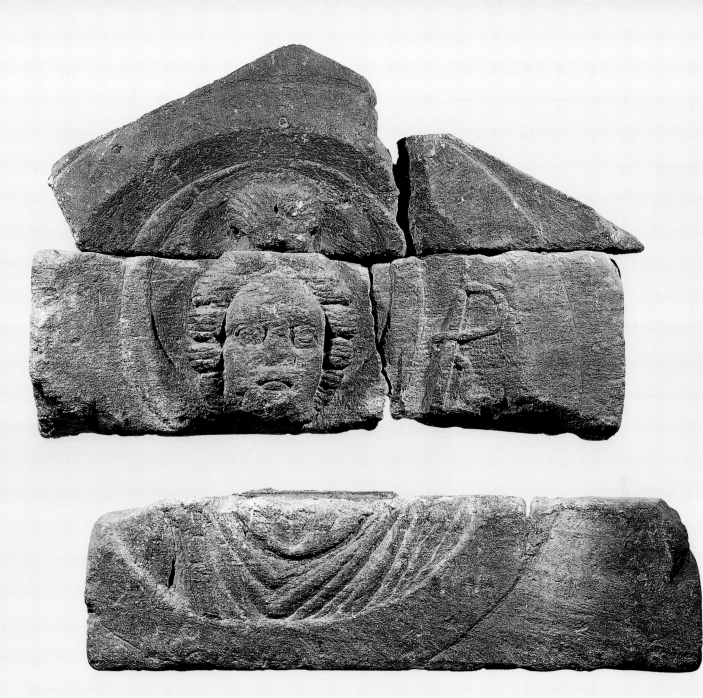

Above: Relief carving of the goddess Luna which decorated one of the buildings in the Temple precinct. The disc of the moon can be seen behind her head and she holds a whip for driving her chariot across the night sky.

Symbols of the Goddess

The elaborately carved pediment of the Temple would have been rich in meaning for native and Roman visitors, although its significance is only partly understood by us today.

Dominating everything is a large roundel or shield bearing a head with fearsome flowing hair and held aloft by two winged Victories. Creatures called tritons neatly fit the awkward triangular corners and immediately below the shield are two helmets, one with an owl perched on it.

The helmets and the owl are clear references to Minerva's attributes of military prowess and wisdom. So, at least superficially, is the head on the shield if it is interpreted as the Gorgon's head cut off by Perseus and carried thus so that those who saw it would be turned to stone. Minerva is frequently shown with a shield of this kind. But there are difficulties, for the head, though closely similar to the female Gorgon, is blatantly male and in his flowing hair and wings there are clear similarities to the sea gods Oceanus or Neptune, an allusion further echoed by the tritons. But if the hair is regarded as flaming and the small star above is significant, they may also be references to the sun god Sol.

These are difficult matters for us to penetrate, just as modern Christian iconography would be puzzling in the extreme to a Roman. Perhaps the sculptor was giving deliberately enigmatic glimpses of the many powers and forms of the presiding deity, Sulis Minerva. The Temple pediment, like the sanctuary it dominated, is a brilliant evocation of the fusion of native and Roman and, perhaps more than any other icon, represents the unique character of Roman Britain.

Right: The powerful face of the Gorgon dominated the Temple precinct from the top of the Temple building. It was probably brightly painted in the Roman period.

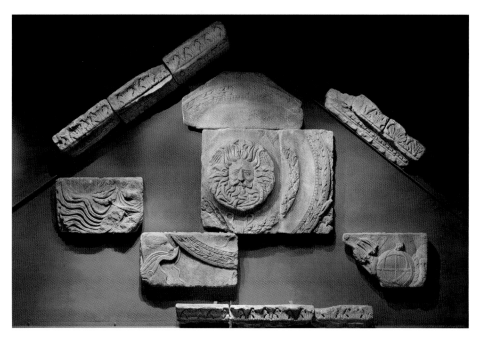

Right: These carved blocks from the pediment of the Temple of Sulis Minerva were discovered during the construction of the present Pump Room in 1790.

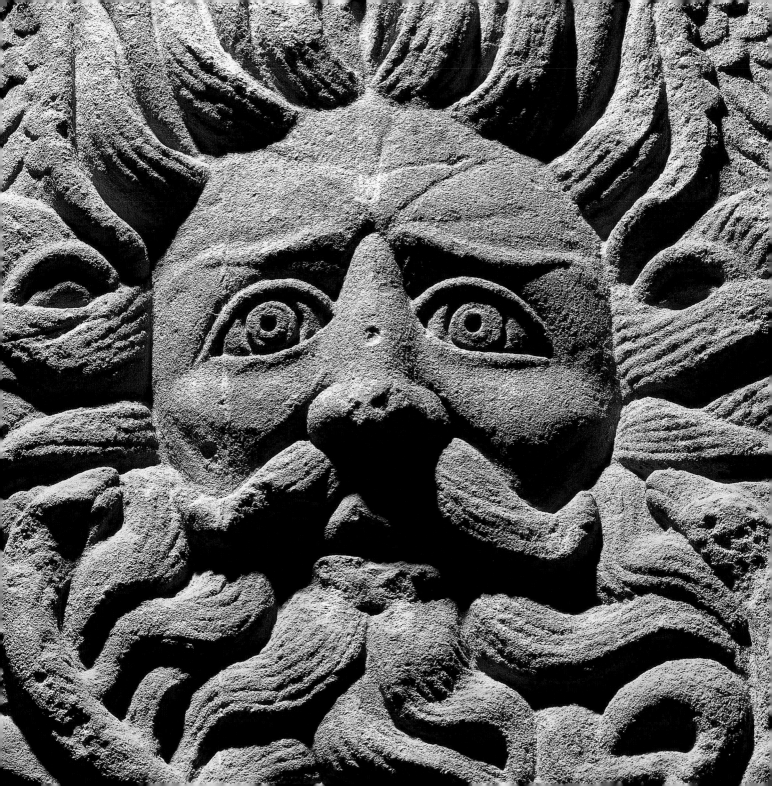

300 years of change

At the time the Baths were built in the late first century AD they were elegant in their simplicity. As time went on and the facilities were extended, the complex took on a more complicated appearance. First the West Baths were provided with a *laconicum*, a circular room offering an intensely hot, dry atmosphere like a sauna, and the cold plunge Circular Bath was inserted into the old entrance hall. At about the same time a completely new suite of baths was added at the east end.

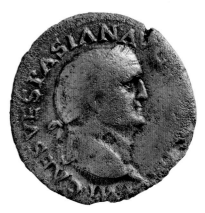

The most dramatic change came in the mid- to late second century when the timber roofs of the Great Bath and entrance hall (by now containing the Circular Bath) were removed, quite possibly because they had started to warp or rot. The walls and piers were then strengthened to support new vaults of tile and concrete flung with assurance across these considerable spaces. Re-roofing on this scale was a remarkable engineering achievement.

Thereafter the Baths continued to be modified and extended. Nowhere is this more apparent than at the east end where the different floor levels can be seen today. In a final stage it seems that the hypocaust (underfloor heating) systems had begun to be susceptible to flooding and it was necessary to raise all the floor levels.

Above: *Sestertius* of the Emperor Vespasian (AD 69–79) from the Sacred Spring. Its rim was clipped to mark it as the property of the Goddess.

The Baths and Temple were completed around AD 75 during the reign of Vespasian. Coins of Nero (AD 54–68) and Vespasian were the first to be thrown into the spring in large numbers.

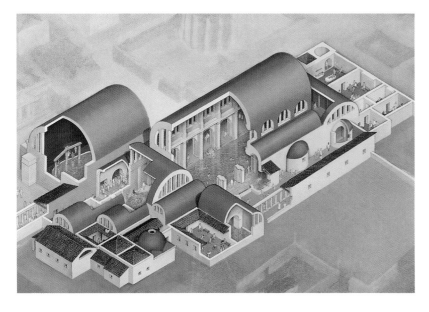

Left: Artist's impression of the Baths and Sacred Spring at their greatest extent in the in the fourth century. Today the visitor can see the full extent of the complex from east to west ends.

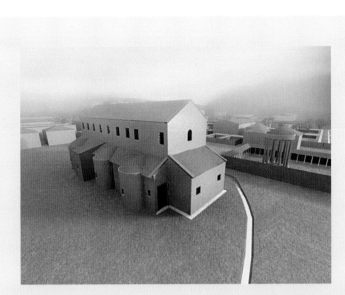

▲ Computer reconstruction of the first to second century bath-house viewed from the south east. This was before any heated rooms were added at the eastern end.

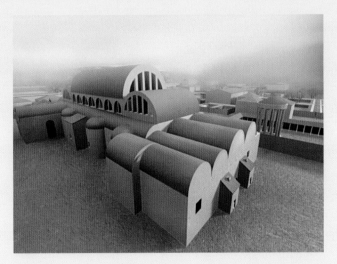

▲ The Baths in their final form in the fourth century. The eastern range of heated rooms in the foreground had now become a large and complicated building.

The sequence of ground plans shows how the Baths developed. They started as three warm pools fed from the Sacred Spring and a simple suite of heated rooms at one end. The final bath-house was a sophisticated complex offering a wide range of treatments and facilities.

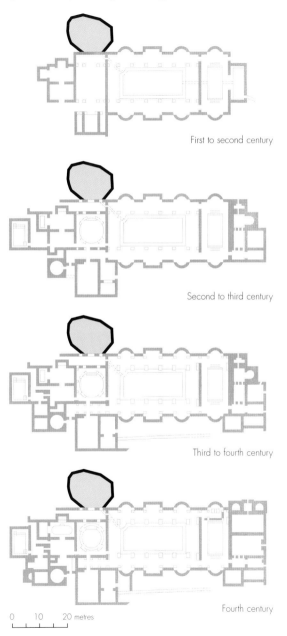

First to second century

Second to third century

Third to fourth century

Fourth century

0 10 20 metres

39

Later in the life of the Baths, a length of lead pipe was set into the paving on the north side of the Great Bath. It was to take a constant supply of water to a fountain in the form of a reclining water god, now almost unrecognisable through weathering, on the north side of the bath.

The Baths today are a remarkable monument to the skill of the Roman engineers who built and maintained them over more than three centuries of public service.

Development and change

The Baths and Temple saw many changes during their 300-year history as bathing practices changed, demand increased or maintenance became necessary. Sometimes these developments cannot be dated accurately.

The Baths and Temple were separate complexes on opposite sides of the Sacred Spring. Without precise dating evidence it is not possible to tell whether changes to one of them took place at the same time as changes to the other.

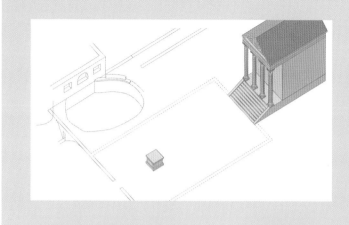

Left: In its earliest form the Temple stood on a podium at the top of a flight of steps. The Sacred Spring rose in a polygonal tank which was open to the sky.

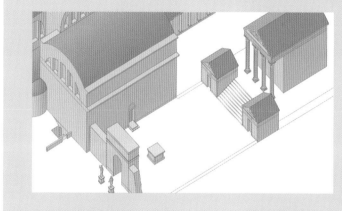

Left: In the late second or early third century the podium was extended to create a walkway around the Temple and two small shrines were added at its front. The Sacred Spring was enclosed within a massive vaulted chamber.

Left: Later, massive stone buttresses and a central portico were built in the Temple precinct to support the north wall of the Sacred Spring building which had become unstable.

10 m

5

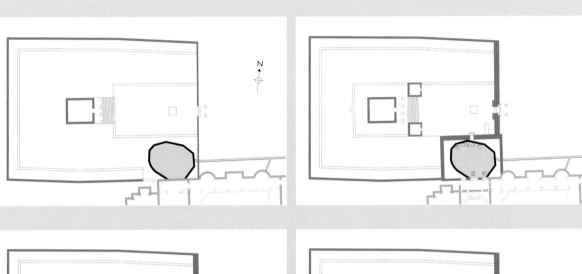

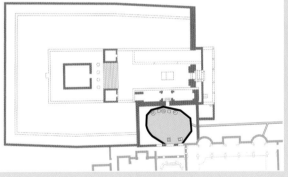

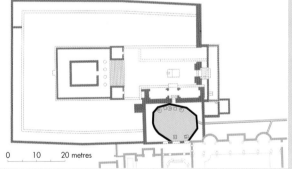

0 10 20 metres

Above: Four plans showing the development of the Temple and Sacred Spring buildings between the first and fourth centuries. After the construction of its cover building the Sacred Spring was only accessible from the Temple precinct through a narrow doorway. Its worn steps can still be seen today.

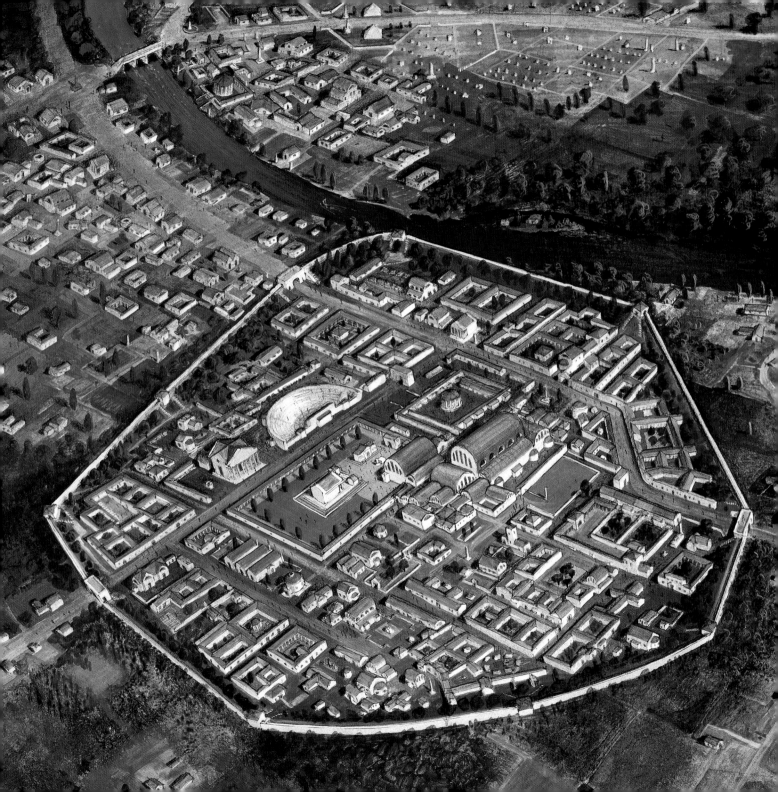

Roman Bath

The Baths and Temple were functioning by about AD 75. By the late first century, civilians including women were visiting, doubtless to pay their respects to the Goddess and seek a cure in the healing water. The settlement became known as *Aquae Sulis* (the Waters of Sulis) in honour of the presiding deity, although the second century Greek geographer Ptolemy recorded it as *Aquae Calidae* (Hot Waters).

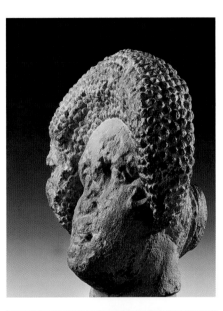

Opposite: Artist's impression of *Aquae Sulis*, showing it as a small walled settlement dominated by large public buildings at its centre. Much of the surrounding urban infill is conjectural. Archaeological work in the 1990s established the importance of the undefended suburb along the road approaching from the north (top left on this map).

Aquae Sulis was not a conventional Roman town. Rather it was a destination for pilgrims seeking the guidance of Sulis Minerva and healing in the curative water. Inscriptions in the Museum record people of all kinds – military and civilian, men, women and children, with known ages from 18 months to 86 years. Some travelled long distances to erect their altars, such as Peregrinus from Trier in Germany. Others lived closer to home – Sulinus, son of Brucetus, was a local sculptor who also had a workshop in *Corinium* (Cirencester).

In addition to the Baths and Temple of Sulis Minerva, the walled area around the hot springs contained several other major public buildings. These probably included another bath-house, shrines over the two smaller springs, a theatre and an unusual circular temple or *tholos* where Bath Abbey now stands. Mosaics found nearby probably represent priests' residences or pilgrims' lodgings, and the resident population most likely lived in an artisan quarter alongside the main road to the north.

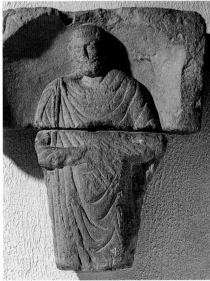

Right: Tomb sculpture can give us a picture of the people who were visiting and perhaps living in *Aquae Sulis,* even if there are no inscriptions to give us their names. The large stone head (top) commemorated a wealthy lady, datable to the late first century by her hairstyle. The figure in the niche (below) is a civilian man wearing a cloak and possibly holding a document or scroll.

Decline and decay

Britain was increasingly beleaguered by barbarian raids from northern Europe and Ireland during the fourth century. Villas around Bath were attacked and burned; many were not reoccupied, the survivors preferring to seek refuge within the walls of *Aquae Sulis*. The very late presence of a hypocaust room with mosaics in the outer Temple precinct suggests there was intense demand for building land within the walls.

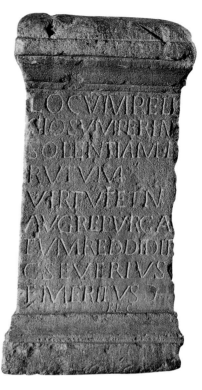

Right: While the brick and tile roof over the Great Bath and its upper walls eventually collapsed into the abandoned building, the massive moulded pier bases remained *in situ* and were buried in the swamp that engulfed the Baths.

Left: Altar recording the desecration of 'this holy place by insolent hands' and its repair by G. Severius, centurion of the region. This may refer to damage caused to the Temple buildings by barbarian raiders.

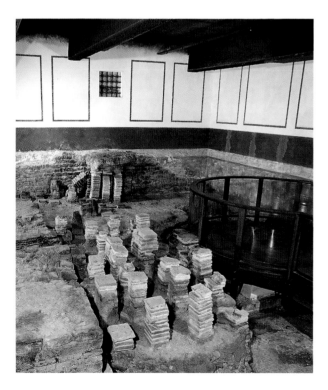

Amidst the growing instability, travel became unsafe. The number of visitors to the bathing establishment declined, although small numbers of coins continued to be deposited in the spring up until the end of the fourth century. At the same time flooding from the River Avon up the drains made maintenance of the Baths increasingly difficult. Floor levels in the East Baths were raised on more than one occasion to escape the rising water levels.

On the other side of the Sacred Spring, mud and rubbish started to accumulate in the inner Temple precinct, and exposed fragments of decorated stonework fell or were knocked off the Temple buildings. For a while tips of rubble were laid from time to time in the Temple precinct to consolidate the mud, but eventually the rising water won and black mud covered everything. It was into this mud that the Temple buildings eventually collapsed or were pulled down. In the Baths, the roofs eventually gave way and crashed into the growing swamp.

Left: The eastern range of Baths was prone to flooding as it was closest to the river and adjacent to the main drain. Water backing up the drain into the Baths would have doused the furnaces and rendered the underfloor heating useless. Floor levels were repeatedly raised to escape this threat and remains of the highest can be seen attached to the east wall of the *caldarium*.

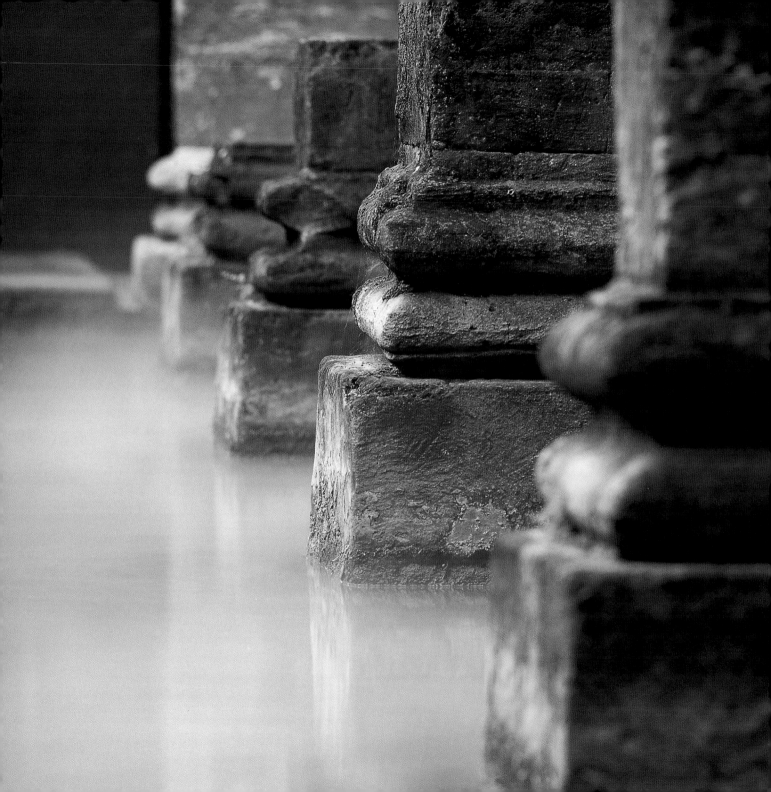

Water is best

The legend 'Water is Best' is boldly proclaimed in raised Greek lettering on the entablature of the Grand Pump Room's north elevation. Installed in the mid 1790s when the fortunes of the eighteenth century spa were already on the wane, it was nonetheless intended as a reminder to all who pass by of the pre-eminence of Bath's unique thermal water.

Left: The present Pump Room, opened in 1795, is the second such building to stand on this site. It is still a popular place to meet, take refreshments and drink a glass of the curative spa water.

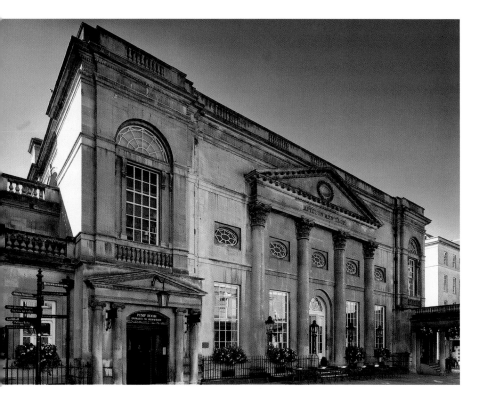

Above: The north elevation of the present Pump Room. The engaged form of a classical temple portico is a reminder that it was when this building was constructed that the remains of the Roman Temple were found directly below it.

The hot springs have been a source of fascination since earliest times, long before the Romans arrived in Bath. Even after their departure, the water continued to flow through their ruined buildings and the earliest Saxon name for Bath, Hat Bathu (Hot Baths) indicates an enduring compulsion to get into the water. By the twelfth century the King's Bath, formed within the shell of the Roman reservoir chamber, was enclosed within the precincts of the post-Roman monastery. Medieval medical practice promoted the practice of bathing in the hot water for ailments such as leprosy (meaning any skin complaint), gout, palsy and colic.

In the late seventeenth century doctors were recommending drinking the water as a remedy for internal conditions, and the first Pump Room, opened in 1706, placed drinking prescribed quantities of the water at the heart of the emerging spa culture. The practices of both drinking and bathing in the spa water remained popular well into the twentieth century.

Although bathing in the King's Bath is no longer possible, the spa water fountain remains a central feature of life in the Pump Room, where a taste of the water that led to the foundation of *Aquae Sulis* nearly 2000 years ago is an essential part of a visit today.

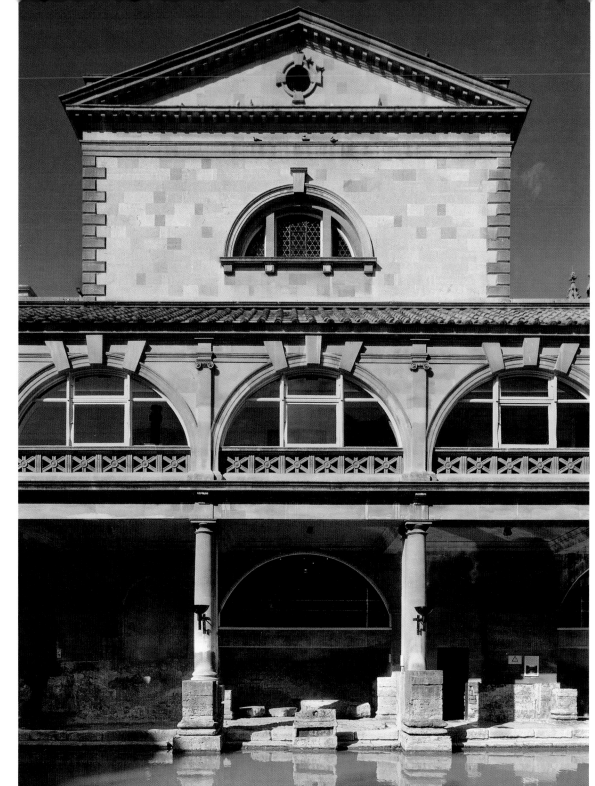

Right: The south elevation of J. M. Brydon's Pump Room extension, built in 1895–97 following the discovery of the Roman Baths. The upper building, the Concert Room, provided additional entertainment facilities for the Pump Room. It was surrounded by marble corridors which extended along the covered terrace overlooking the Baths. The area below these structures became the Roman Baths Museum, which it still is today.

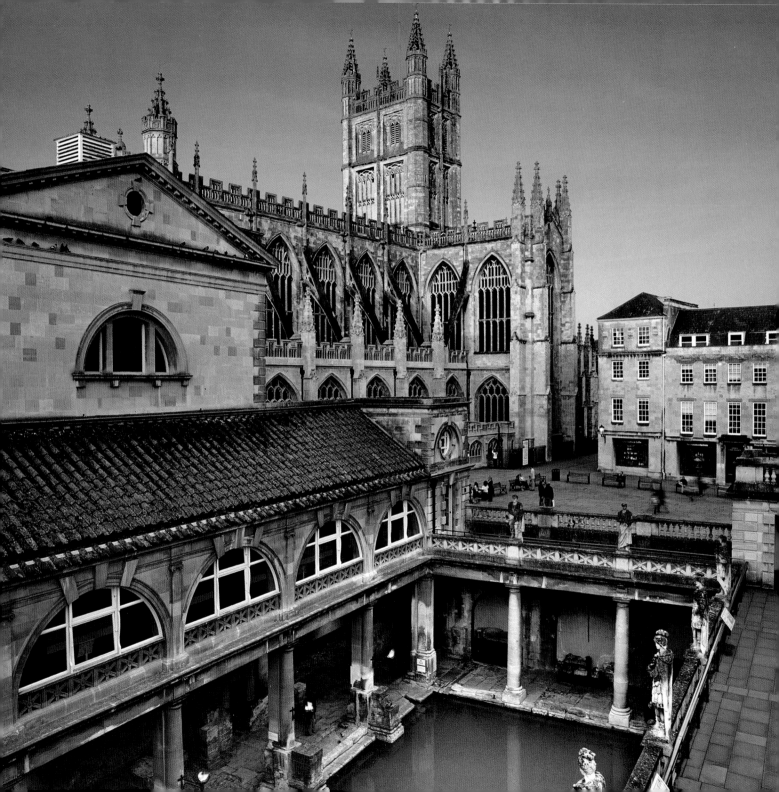